IF I WERE A BOOK

BY JOSÉ JORGE LETRIA

ILLUSTRATIONS BY ANDRÉ LETRIA

CHRONICLE BOOKS

SAN FRANCISCO

IF I WERE A BOOK,
I'D ASK SOMEONE IN THE STREET
TO TAKE ME HOME.

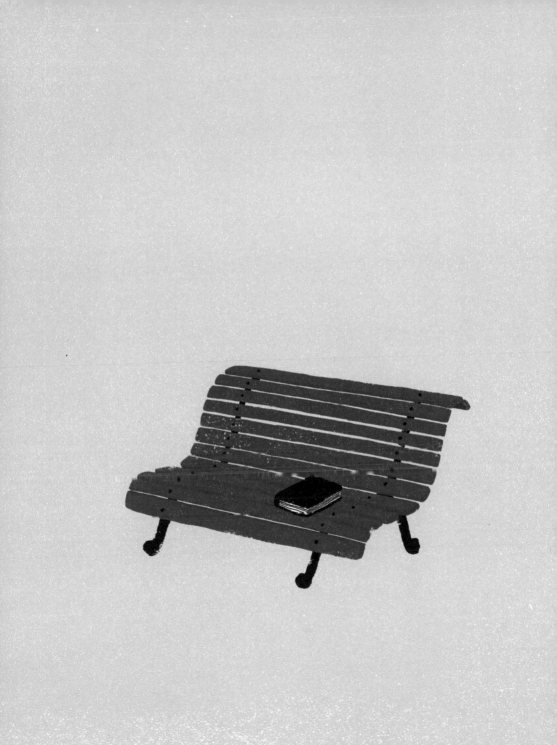

IF I WERE A BOOK,
I'D SHARE MY DEEPEST SECRETS
WITH MY READERS.

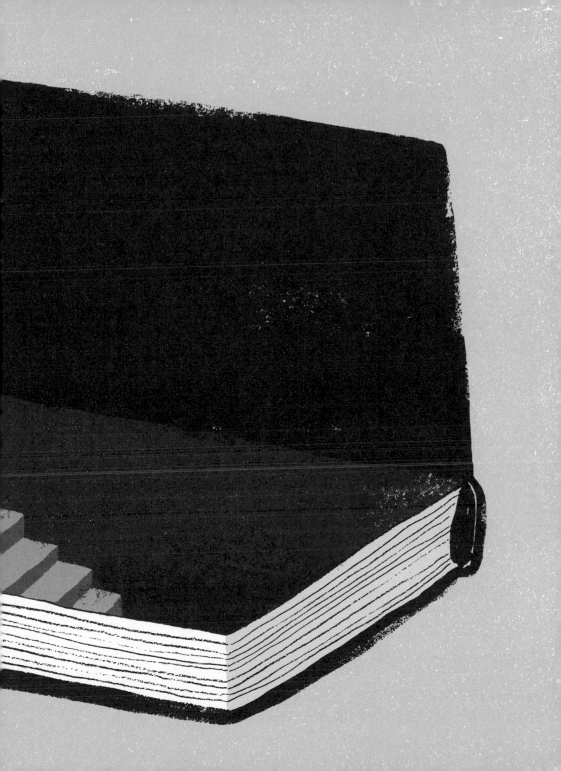

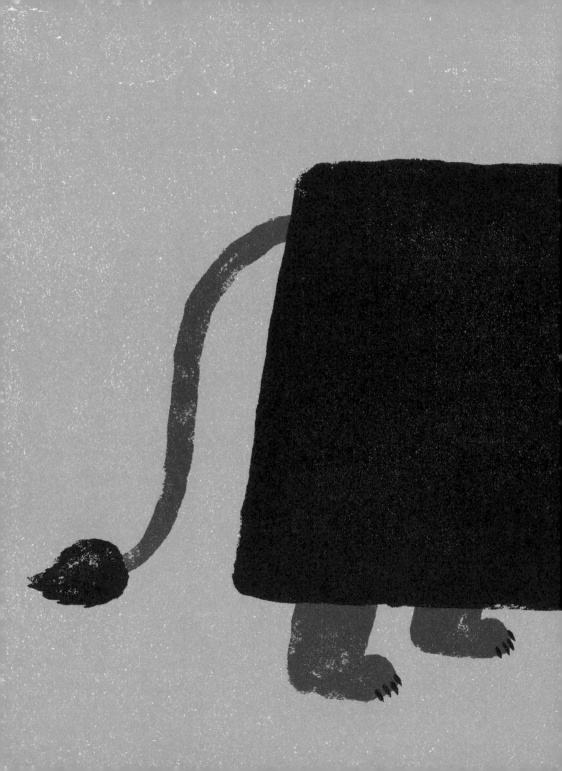

IF I WERE A BOOK,
I'D LIKE TO HAVE MY OWN MAGICAL PLACE
IN EVERY CHILD'S IMAGINATION.

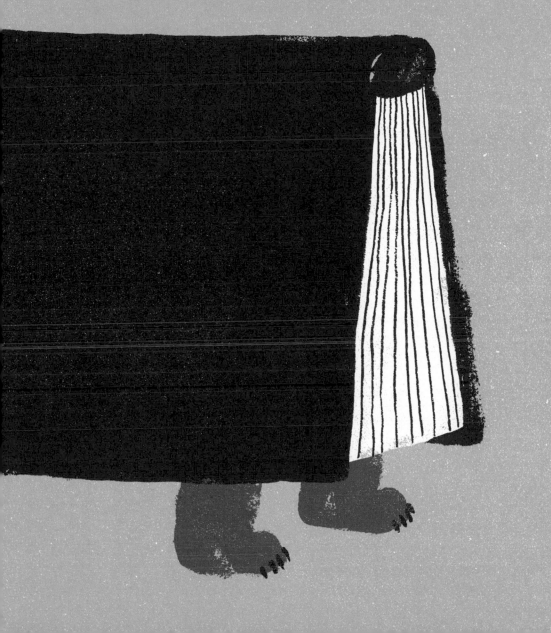

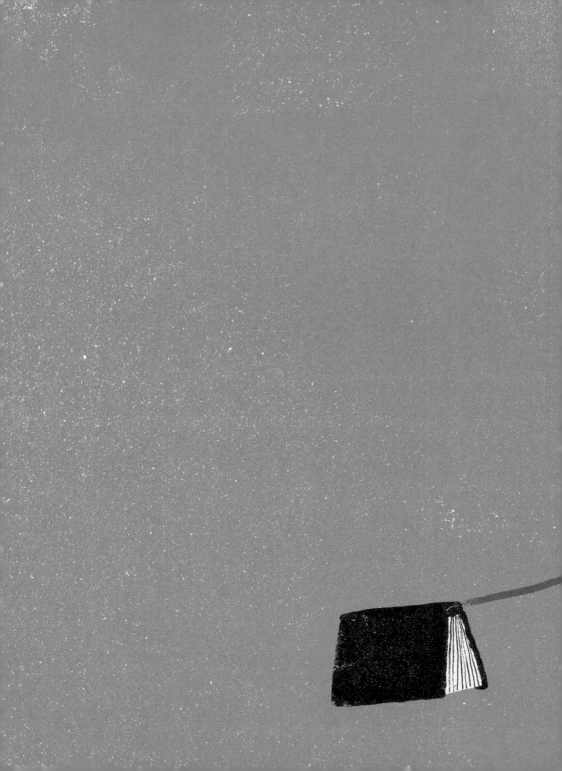

IF I WERE A BOOK,
I'D BE YOUR BEST FRIEND.

IF I WERE A BOOK,
I'D BE FULL OF USEFUL KNOWLEDGE.

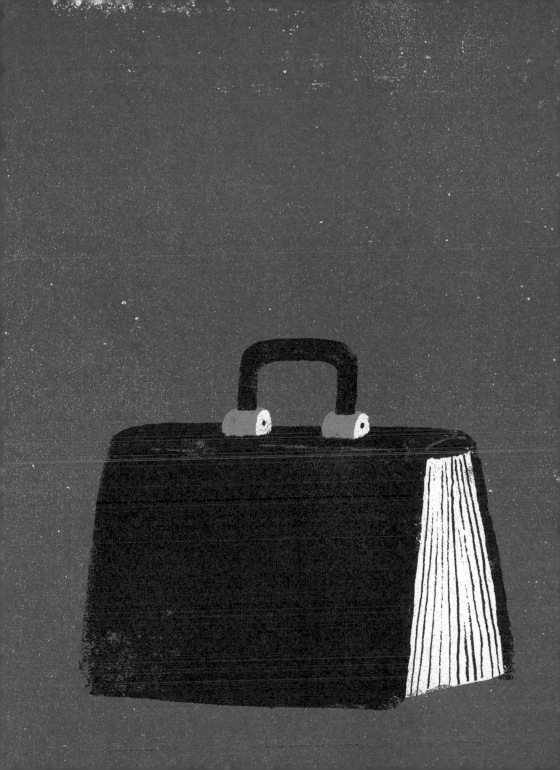

IF I WERE A BOOK,
I'D LIKE TO BE READ LATE AT NIGHT
IN A SLEEPING BAG WITH A FLASHLIGHT.

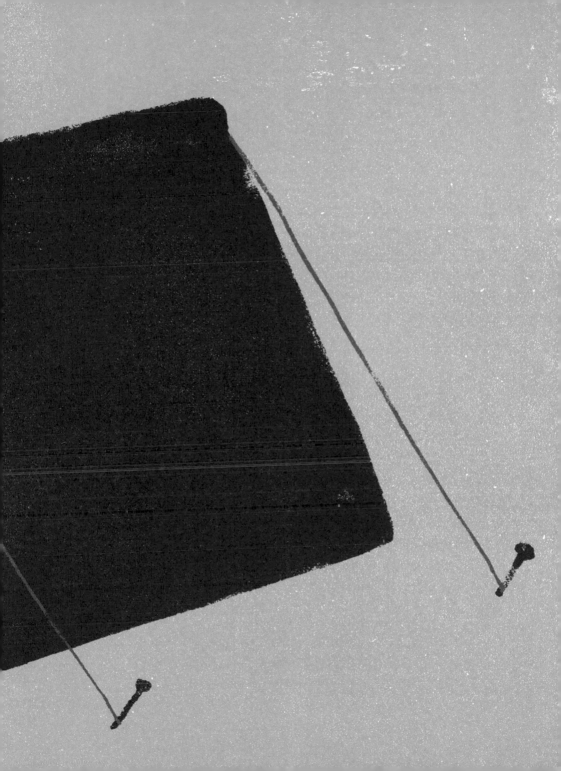

IF I WERE A BOOK,
I WOULD NOT WANT TO KNOW AT THE BEGINNING
HOW MY STORY ENDS.

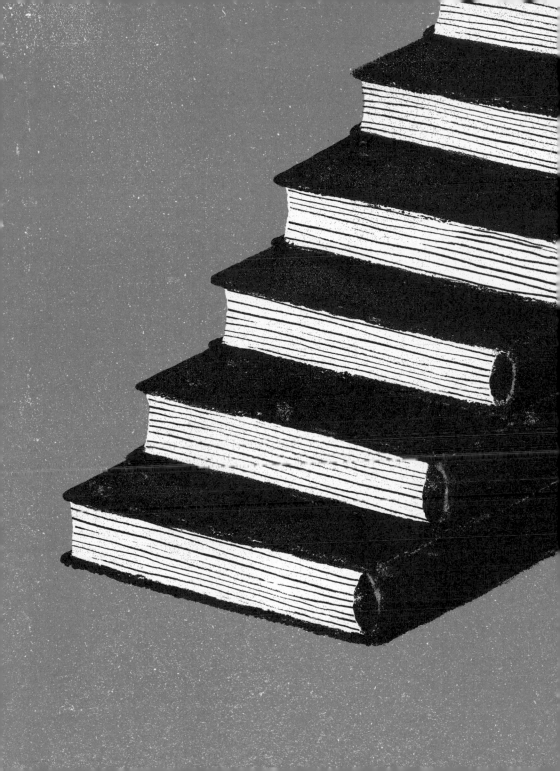

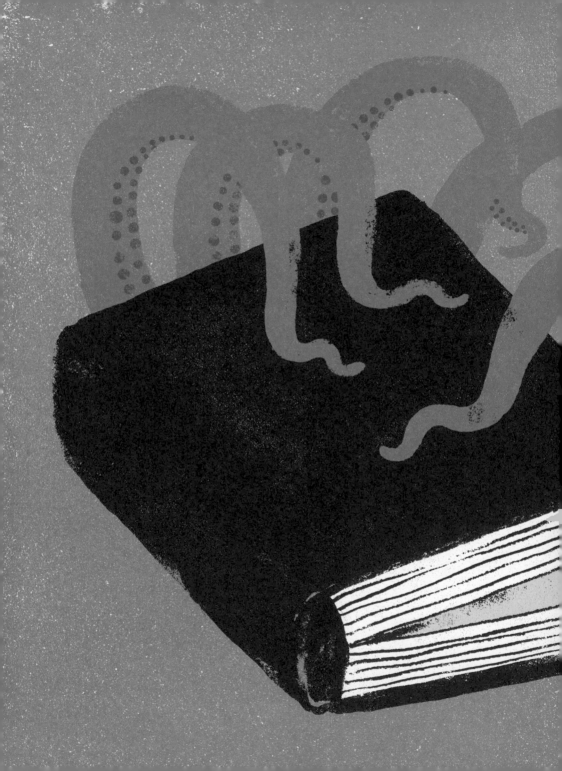

IF I WERE A BOOK,
I'D CAPTURE YOU WITH MY CAPTIVATING TALES.

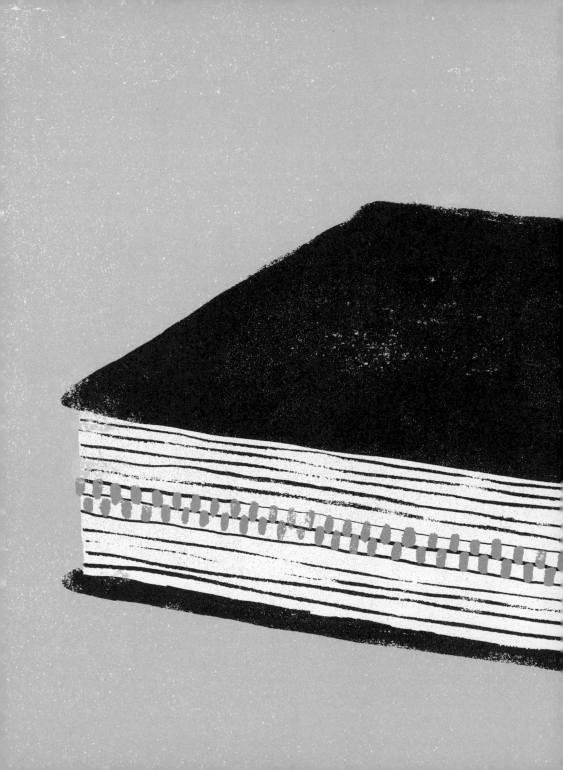

IF I WERE A BOOK,
I'D KEEP ALL THE SECRETS
CONFIDED TO ME BY MY READERS.

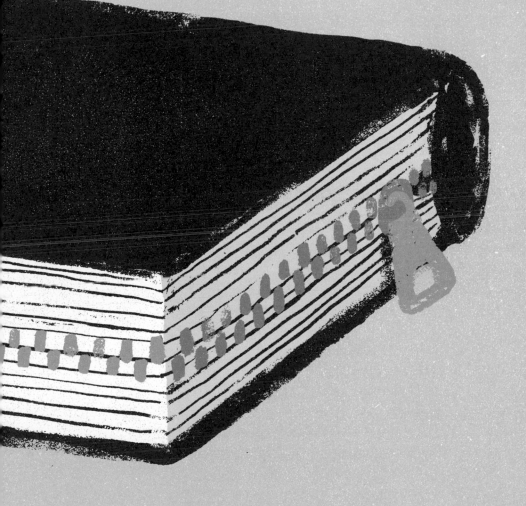

IF I WERE A BOOK,
I'D BE IN NO HURRY TO REACH
THE WORDS "THE END."

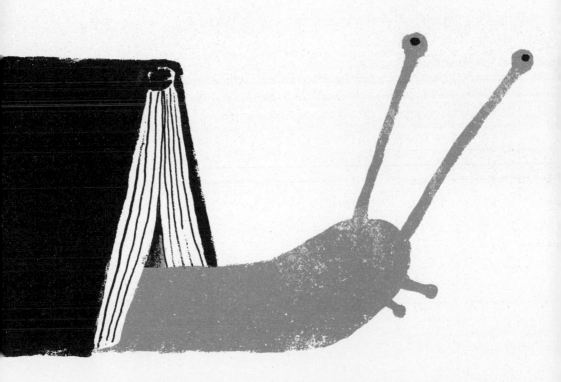

IF I WERE A BOOK,
I WOULD NOT LIKE TO BE READ
OUT OF OBLIGATION.

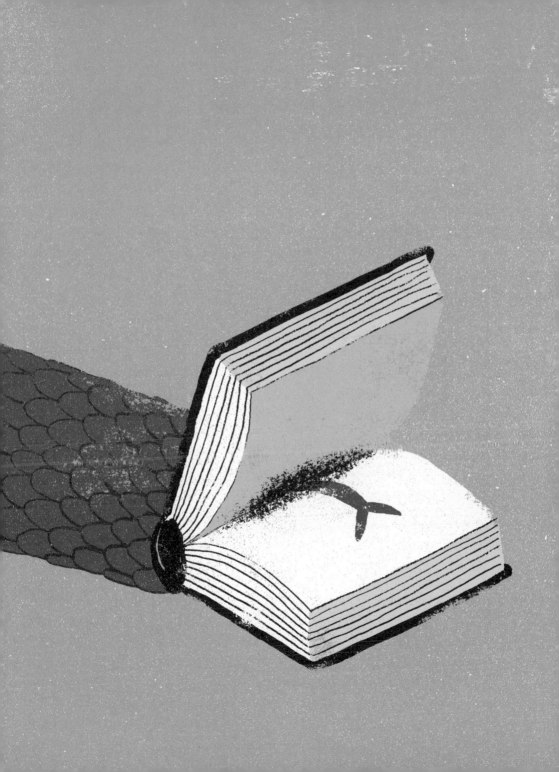

IF I WERE A BOOK,
I'D BE ONE SKYSCRAPER
IN THE CITY OF WORDS.

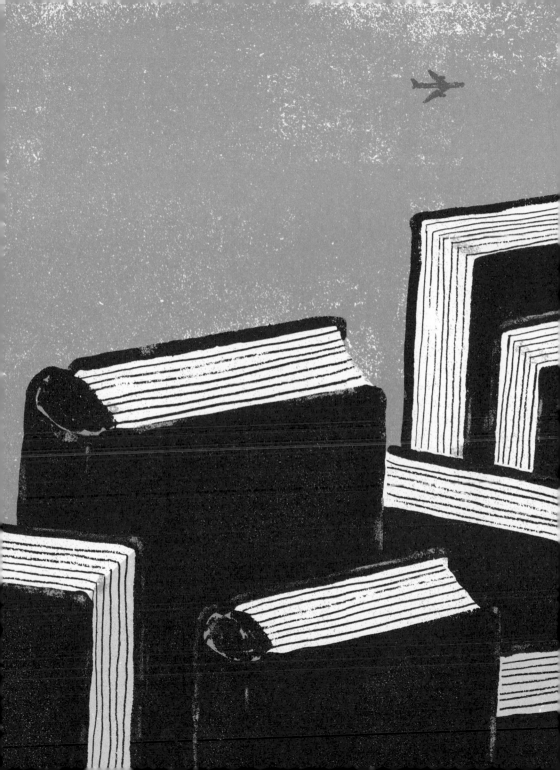

IF I WERE A BOOK,
I'D LIKE YOU TO DIVE IN AND FIND TREASURES.

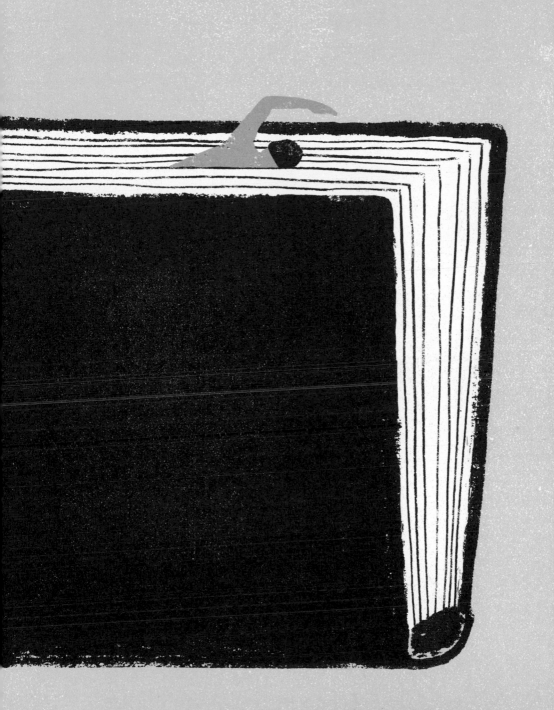

IF I WERE A BOOK,
I'D HELP SOMEONE SOAR.

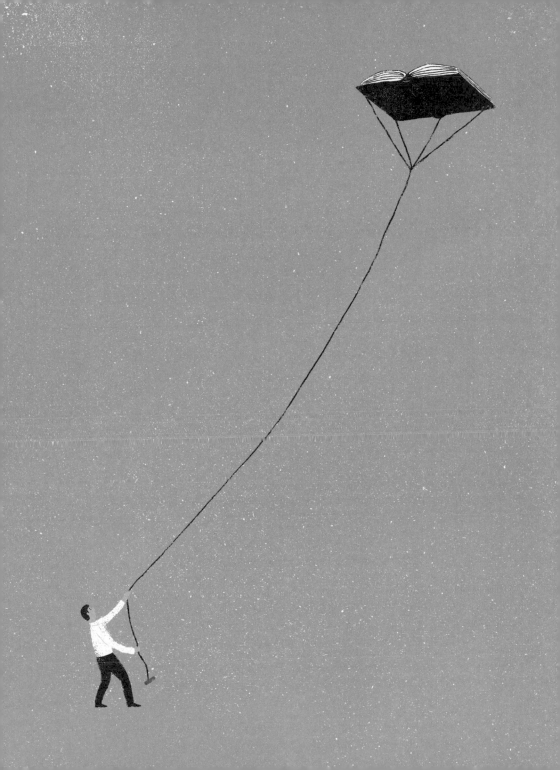

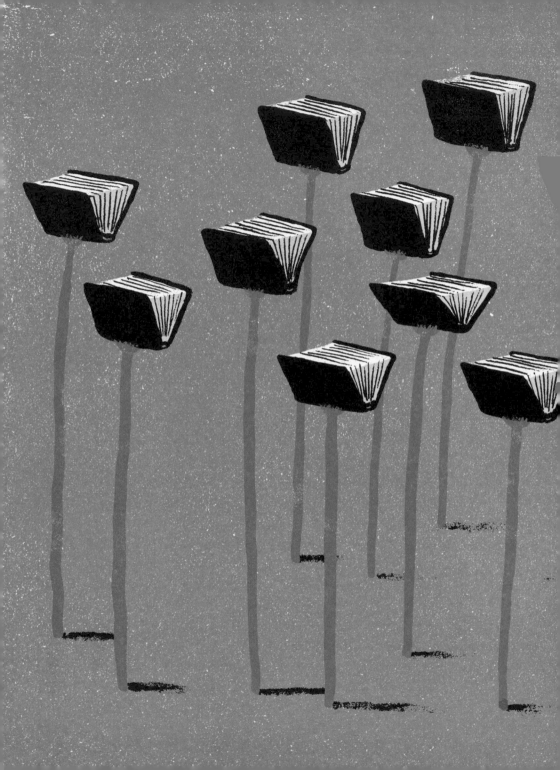

IF I WERE A BOOK,
MY SCENT WOULD BE THE BOUQUET
OF AN ENDLESS AND UNEQUALED DAY.

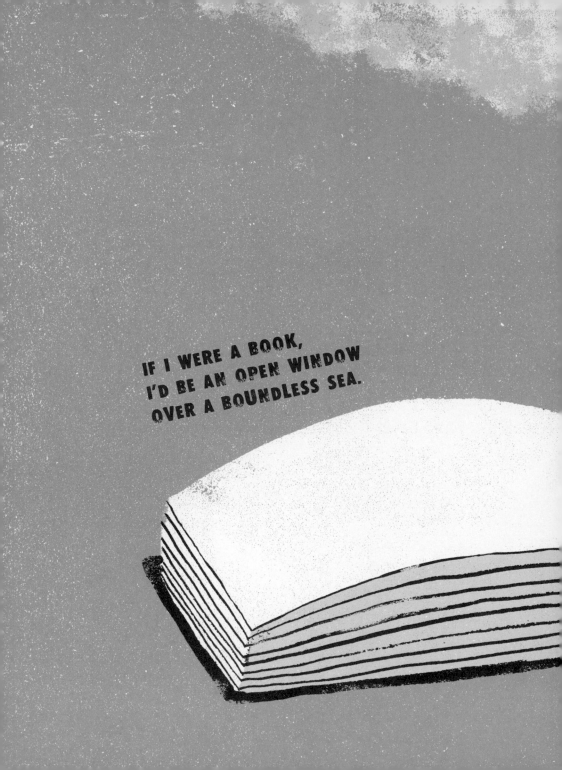

IF I WERE A BOOK,
I'D BE AN OPEN WINDOW
OVER A BOUNDLESS SEA.

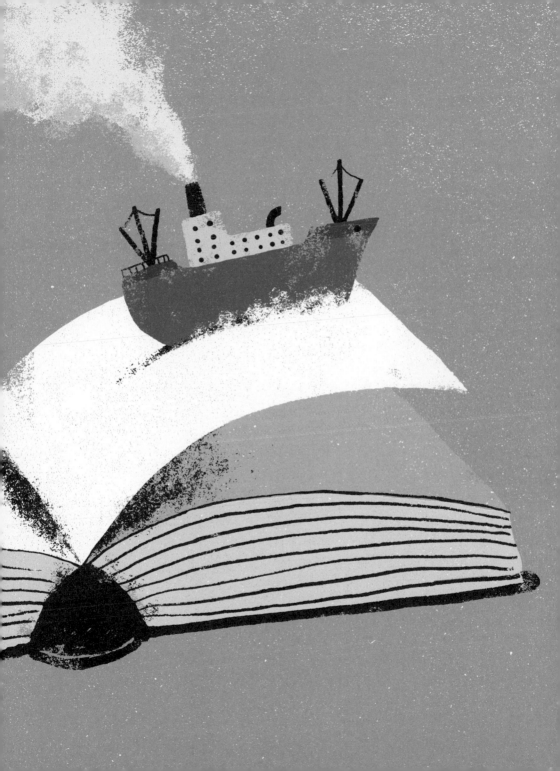

IF I WERE A BOOK,
I'D CONTAIN POEMS THAT LIGHT UP THE NIGHT.

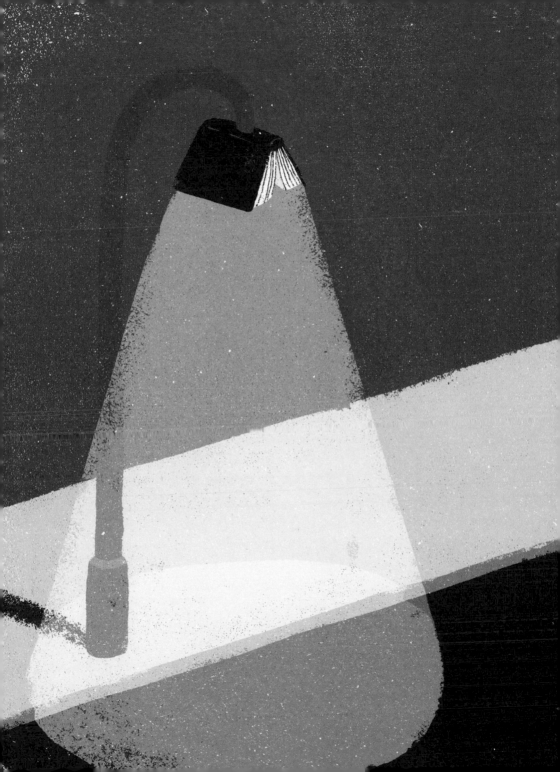

IF I WERE A BOOK,
I'D LIKE, ABOVE ALL THINGS, ALWAYS TO BE READ
AND ALWAYS TO BE FREE.

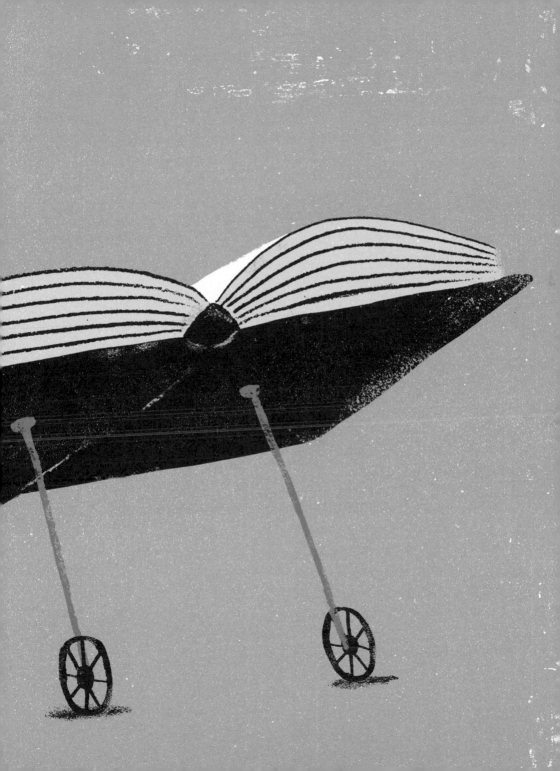

IF I WERE A BOOK,
I WOULD SWEEP AWAY IGNORANCE.

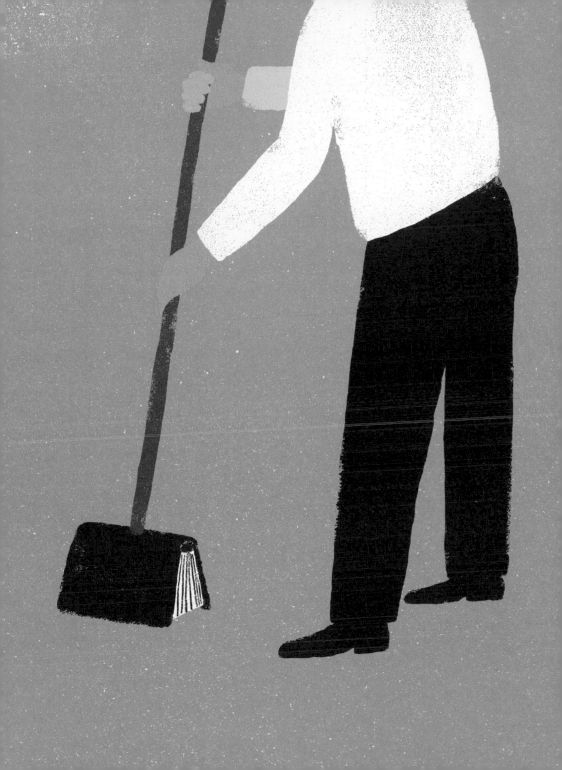

IF I WERE A BOOK,
I WOULDN'T WANT PEOPLE TO
ONLY PRETEND TO HAVE READ ME.

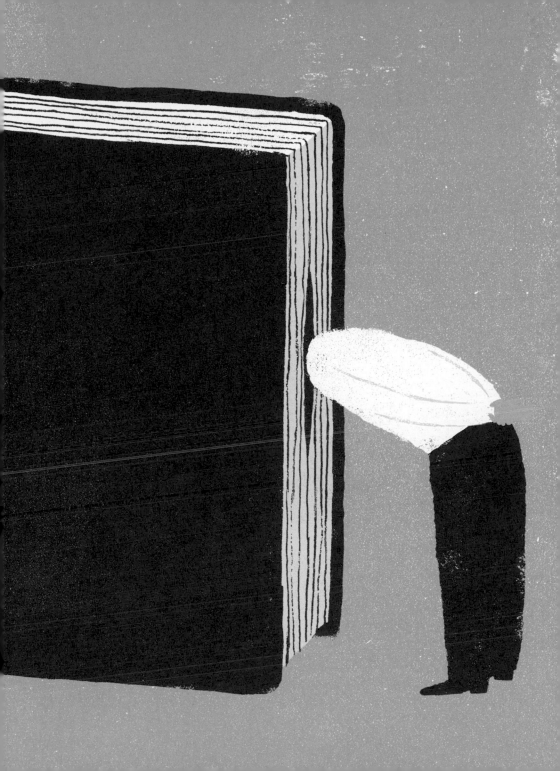

IF I WERE A BOOK,
I'D HELP ANCHOR YOU TO YOUR TRUEST SELF.

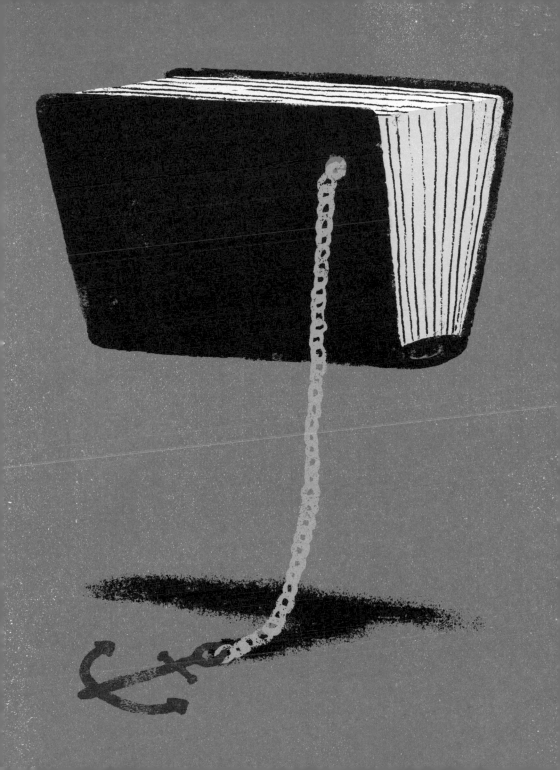

IF I WERE A BOOK,
I'D TAKE READERS TO THE WIDE OPEN SPACES
OF THEIR OWN UNTAMEABLE MINDS.

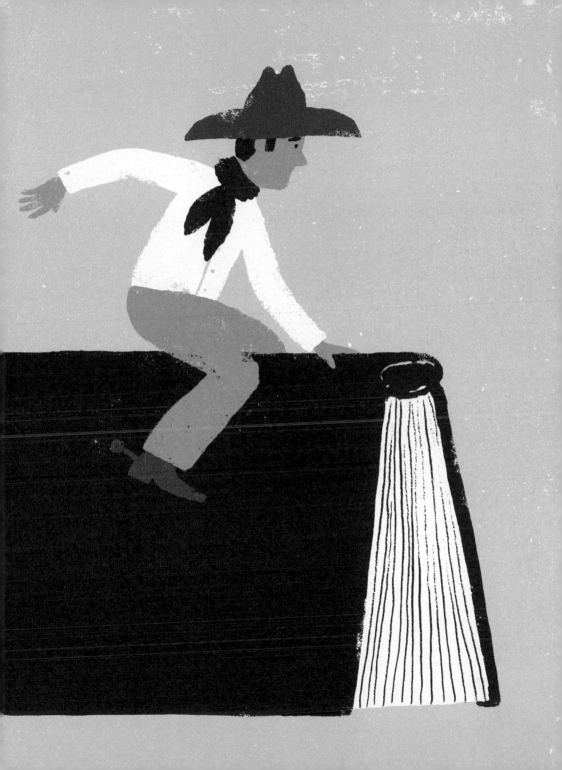

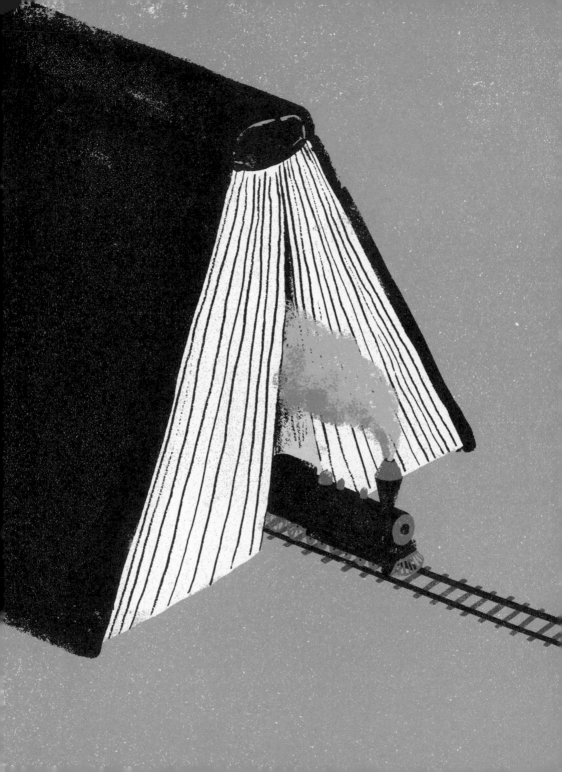

IF I WERE A BOOK, I'D BE AN ENDLESS JOURNEY.

IF I WERE A BOOK,
I'D CRUSH VIOLENCE WITH KNOWLEDGE.

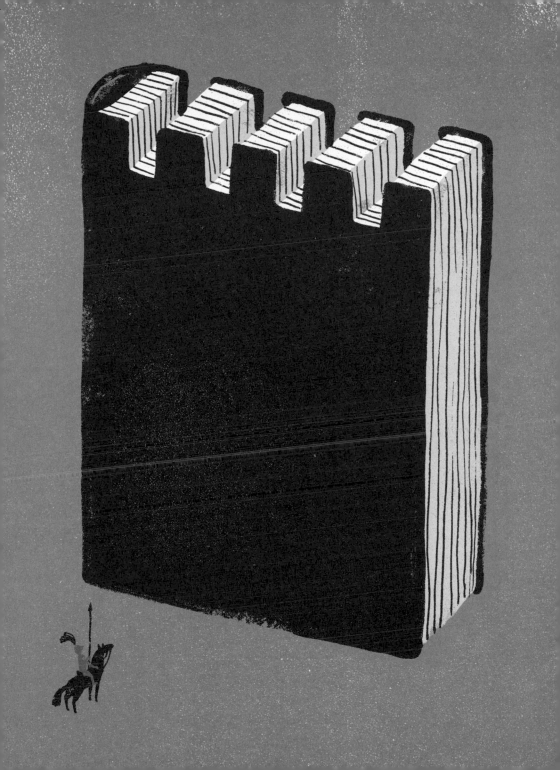

IF I WERE A BOOK,
I'D BE HAPPY TO WIND UP ON A DESERT ISLAND
WITH A PASSIONATE READER.

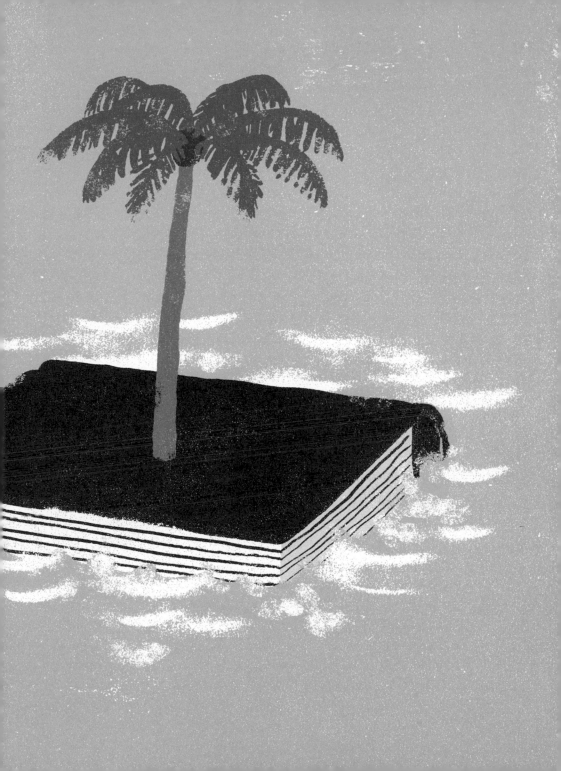

IF I WERE A BOOK,
I'D TAKE ON ALL THE FORMS THAT TIME
MIGHT CARE TO BESTOW UPON ME.

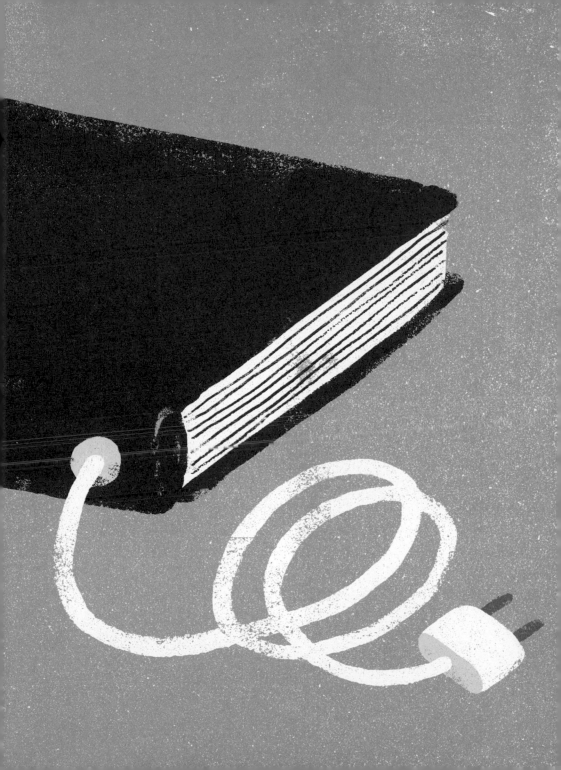

IF I WERE A BOOK,
I'D BE FULL OF NEW HORIZONS.

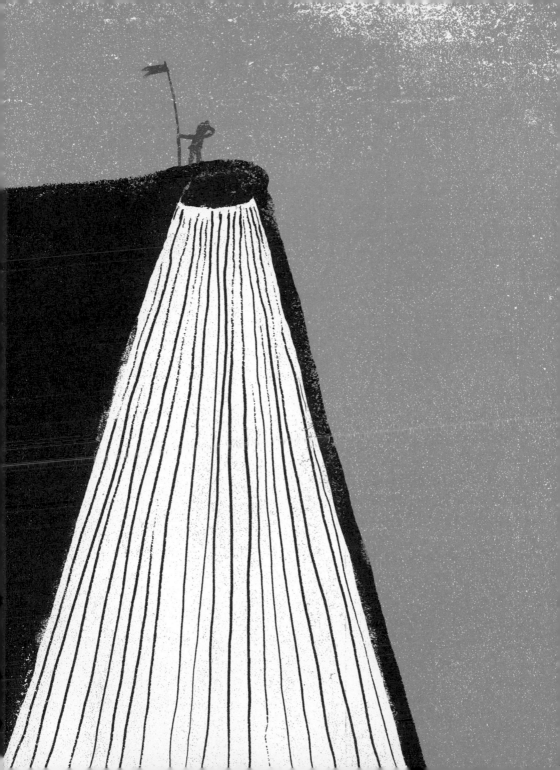

IF I WERE A BOOK,
I'D LIKE MORE THAN ANYTHING
TO HEAR SOMEONE SAY,
"THIS BOOK CHANGED MY LIFE."

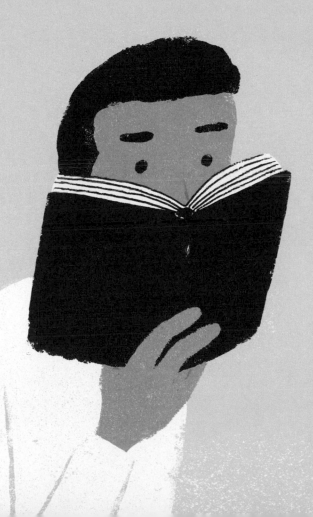

FIRST PUBLISHED
IN THE UNITED STATES
OF AMERICA IN 2014 BY
CHRONICLE BOOKS LLC.

FIRST PUBLISHED IN PORTUGAL IN
2011 BY PATO LÓGICO EDITIONS, Lda

LIBRARY OF CONGRESS CATALOGING-IN-PUBLICATION
DATA AVAILABLE. ISBN: 978-1-4521-2144-4

MANUFACTURED IN CHINA.

TRANSLATED FROM THE PORTUGUESE BY ISABEL TERRY,
WITH ADDITIONAL ADAPTATIONS.

10 9 8 7 6 5 4 3

CHRONICLE BOOKS LLC
680 SECOND STREET, SAN FRANCISCO, CA 94107 · WWW.CHRONICLEBOOKS.COM